TOULOUSE-LAUTREC

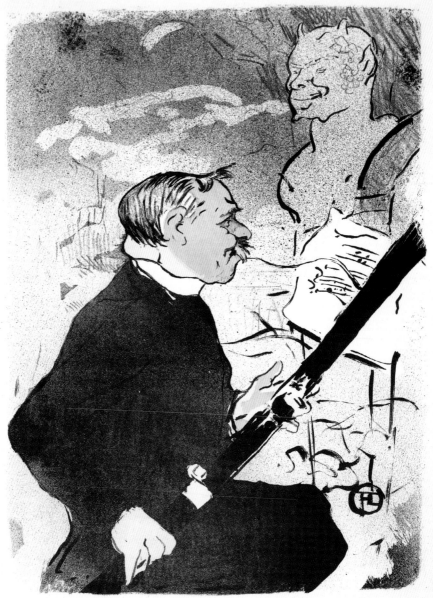

HLautrec

THE BRITISH MUSEUM
TOULOUSE-
LAUTREC

Jennifer Ramkalawon

THE BRITISH MUSEUM PRESS

Jennifer Ramkalawon has asserted the right to be identified
as the author of this work

First published in 2007 by The British Museum Press
A division of The British Museum Company Ltd
38 Russell Square, London WC1B 3QQ
www.britishmuseum.co.uk

A catalogue record for this book is available from the British Library

ISBN-13: 978-0-7141-2656-2
ISBN-10: 0-7141-2656-X

Frontispiece: *Pour toi! . . .*, 1893. Brush, crayon and spatter lithograph,
with stencil colouring by another hand in red, rose, turquoise and brown,
printed on greyish paper, 269 × 192 mm

Photography by the British Museum Department of Photography and Imaging
Designed and typeset in Centaur by Peter Ward
Printed in China by C&C Offset Printing Co., Ltd

INTRODUCTION

Lautrec: a tiny blacksmith with a pince-nez. A little bag divided in two that he puts his poor legs in. Thick lips, and hands like the ones he draws, bony, widely spread fingers and semicircular thumbs. He often refers to short men with an air of implying: 'Well I'm not as short as all that!' . . . He makes you feel bad firstly because he is so little, then so full of life, so kind, punctuating his sentences with little grunts which puff out his lips like the wind blowing draught excluders on a door. He is as big as his name . . . Always the same grunting, always the desire to tell you about things that are 'so stupid that they're interesting'. And bubbles of spit fly into his whiskers.

Jules Renard, 26 November 1894, *Journal: 1887–1910* (Paris, 1984)

THIS EVOCATIVE DESCRIPTION of Henri de Toulouse-Lautrec was written by the author Jules Renard at the height of the artist's powers. Renard paints such a vivid portrait that it is hard to believe that six years later its subject would be dead, his later years plagued by alcoholic excess. Lautrec would leave behind a vast body of work that would instantly conjure up the unmistakable atmosphere of the Belle Epoque, leading the contemporary critic Gustave Geffroy to describe him as 'the quintessential chronicler of Paris'. In his art Lautrec effortlessly managed to combine the outward excitement of the whirling, mesmerizing dances of the cabaret and the unforgettable characters of the café-concert (the closest English equivalent would be the music hall) with the poignant, shadowy lives of prostitutes and the claustrophobic atmosphere of the brothel or 'maison close' (literally 'closed house').

Henri-Marie-Raymond de Toulouse-Lautrec Montfa, to give him his full name, was born in 1864. A scion of an ancient aristocratic family, he was the product of a marriage of first cousins. From them he inherited a genetic disorder which contributed to his dwarfism and other serious health problems from which he would suffer throughout his short life. A series of

unfortunate accidents involving the breaking of first his left and then his right leg, coupled with a severe bone disease that had affected the artist as a child, meant that at the age of sixteen Lautrec's growth was permanently stunted. He never reached a height of more than 1.5 metres. While convalescing, Lautrec spent the tedious hours of recovery filling sketchbook after sketchbook with lively, keenly observed drawings of the growing menagerie of animals collected by his eccentric father. By the time the artist was eighteen, his family allowed him to go to Paris where he studied first with the academic painter Léon Bonnat (1833–1922) and then with Fernand Cormon (1845–1924). One of his fellow pupils at Cormon's atelier was Vincent van Gogh, who greatly admired Lautrec's work.

In 1884 Lautrec settled in the notorious district of Montmartre, famed for its nightclubs and dance halls. He soon embraced the lifestyle of a young bohemian artist, by day frequenting galleries and museums and by night getting uproariously drunk at local establishments. These included Le Chat Noir, a cabaret owned by Aristide Bruant, subject of one of Lautrec's most famous posters (*Les Ambassadeurs*, 1892), and the Moulin Rouge, Lautrec's favourite dance hall, filled with roughnecks and prostitutes, which was immortalized in his work countless times. Montmartre would be Lautrec's home for the rest of his life.

Many of Lautrec's works focus on a single figure with whom he would be obsessed for a period of time. Actresses and music-hall stars were often the objects of these 'furias', as Lautrec called them. They included the dancers Louise Weber (known as 'La Goulue'), depicted in Lautrec's first poster of 1891, and Jane Avril, who became a close friend of the artist, and the singer Yvette Guilbert, for whom Lautrec produced numerous images, including two albums of prints. Lautrec loved the world of the music hall and the theatre, especially life behind the scenes, and enjoyed depicting actors and actresses in various situations, from straightforward portraits to rehearsing backstage or in character on stage. Lautrec's subject matter of dancers, music-hall artists and women in intimate surroundings echoes that of Edgar Degas a decade or so earlier. Lautrec was deeply influenced by

Degas, but brought an audacity and boldness to his subjects that Degas considered 'vulgar'; despite this, the elder artist was deeply impressed by Lautrec's superb skills as a draughtsman.

In contrast to the lively, exuberant scenes of the cafés and bars of Montmartre, Lautrec also portrayed with great sensitivity the extremely private and intimate life of the prostitute. The artist lived briefly in several brothels in the 1890s and captured at first hand the daily rituals of feminine life, beautifully executed in the portfolio *Elles* of 1896. One of the dominant influences on Lautrec's prints of prostitutes was Japanese art. Like many other artists of the period, such as Van Gogh, Lautrec collected Japanese prints. The flatness of the subject, bold use of colour and the importance of outline and simplified line are all elements of Japanese art which are clearly visible in Lautrec's work.

Lautrec produced a huge variety of his work in print form. He made book illustrations, theatre programmes, song-sheet covers, invitations and even menus, as well as illustrations for the growing number of periodicals which were appearing during the latter half of the nineteenth century, due to the growth in literacy rates. Lautrec's work first appeared as drawings reproduced in various magazines, some attached to café-concerts. However, his prints increasingly featured in journals that catered for the discerning print collector, such as *L'Estampe Originale* and *La Revue Blanche*. Lautrec himself was instrumental in setting up one such journal, *L'Escarmouche*, which unfortunately folded after a few months (it ran from 12 November 1893 to 14 January 1894). The prints were usually commissioned by a publisher such as André Marty, owner of *L'Estampe Originale*, or Edouard Kleinmann, who also acted as an agent, commissioning prints and making deals with other publishers on the artist's behalf. At the luxury end of the market, Lautrec produced the *Elles* album for the collector-turned-publisher Gustave Pellet and towards the end of his life he was still trying to complete a commission on horse racing for the publisher Pierrefort. Lautrec also published work through the gallery Boussod, Valadon & Cie, run by his old school friend Maurice Joyant, who had taken over from Theo van Gogh (Vincent's brother).

From his first print, the poster *La Goulue*, Lautrec favoured lithography as his main printing medium; all the prints featured in this book are lithographs. Invented in 1798 by the German Alois Senefelder, lithography involves the artist drawing the image to be printed onto a surface (usually stone) with a greasy medium. The surface is dampened with water and, since grease and water repel each other, the water settles in the unmarked areas. The surface is then covered in greasy printing ink by a roller. The ink sticks to the marks made by the artist, the water repelling it from the rest of the surface. Paper is laid on the stone and run through a scraper press to produce a lithograph. Working with professional printers was essential as the stones needed to be specially prepared; this had to be done in a specialist studio. For colour lithographs, Lautrec would start with one keystone with the image drawn in olive green or brown (sometimes the key-stones were printed as monochrome editions), then he would use one stone for each colour. In his most experimental print, of the dancer Loïe Fuller, the artist used five stones in a wide range of colours; the fourth stone was inked in a rainbow of colours, known as 'iris printing'. After the fifth stone was inked and while the ink was still wet, Lautrec or his printer sprinkled gold or silver powder over the print, creating a shimmering effect. Not surprisingly, no two impressions of this print are alike.

Another technique favoured by Lautrec was a spatter technique, or 'crachis' as it is sometimes known. This involves dipping a small brush in lithographic ink, shaking off the excess, and then running a knife along the surface to produce a spattering of ink. Lautrec used this technique to great tonal effect in many of his prints. However, the majority of the prints produced by Lautrec were monochrome images drawn in crayon. By 1893 Lautrec had abandoned preparatory drawings and was composing his works directly onto the stone.

The British Museum is fortunate to own just over one hundred prints by Lautrec, a substantial collection of prints by the artist outside his native France. The Bibliothèque Nationale in Paris holds the largest collection at 800 prints, many of which are variant impressions and touched or working

proofs donated by Lautrec's mother in 1902. The majority of the British Museum's prints, kept in the Department of Prints and Drawings, are from the generous bequest left to the Department by one of its former keepers, Campbell Dodgson (1867–1948). Dodgson was educated at Winchester and New College, Oxford, where he gained a first in Classics; he was briefly tutor to Oscar Wilde's children before joining the Museum in 1893. A member of the Department of Prints and Drawings for thirty-nine years, and Keeper from 1912 to 1932, Dodgson bought judiciously during his time there. Privately he was amassing a huge collection, mainly of prints but also some drawings, resulting in personal acquisitions totalling around 5,000, with the view of leaving them to the Department on his death. Included in this huge cache were 1,000 French prints by Lautrec and his near contemporaries Bonnard, Vuillard, Manet and Redon. A selection of these prints was shown to the public in an exhibition, *From Manet to Toulouse-Lautrec*, in 1978. Dodgson was careful when purchasing not to duplicate any prints that were already part of the existing holdings of the Department. As a private buyer he could be slightly more adventurous in his tastes than when he was wearing his public-servant hat; this meant that he could concentrate in some cases on buying works by contemporary artists under-represented in the collection at the time, for example Picasso and Matisse.

This book illustrates a selection of the prints by Lautrec that Campbell Dodgson bequeathed to the British Museum. The first part comprises scenes of theatrical life; the second, studies of daily life, including Lautrec's very personal observations of the intimate lives of prostitutes. Though representing a fraction of the remarkable body of work left by the artist, the prints reproduced here give an insight into the wit and astonishing technical and artistic virtuosity which characterize Lautrec's art.

1. *Moulin Rouge – La Goulue*

Commissioned by the proprietor of the Moulin Rouge, Charles Zidler, as a means of attracting new clientele and promoting the stars of his establishment, this poster, Lautrec's first, was an instant success. Displayed outside the Moulin Rouge, it depicted one of its most famous attractions, the dancer Louise Weber (1866–1929), known as 'La Goulue' ('The Greedy One' or 'The Glutton').

Born of humble origins, Weber rose to fame as the wild exponent of the 'chahut', a more risqué version of the can-can ('chahut' means riot in French slang). She was described in a contemporary short story by Fortune du Boisgobey in the *Figaro Illustré* (1891) as 'leaping like a mad goat, bending her body so much as to convince you she was about to break in half, and the folds of her skirt virtually on fire'. The chahut when performed with a partner was known as the 'quadrille naturaliste'; silhouetted in the foreground of the poster is Weber's partner, Jacques Renaudin (1843–1907), known as 'Valentin le Désossé' ('Valentin the Boneless') because he danced as if his sinewy body possessed no bones.

Lautrec's design differs greatly from contemporary theatrical posters, which usually portrayed an anonymous smiling female figure floating in an undefined space. For his image Lautrec has borrowed elements from Japanese design: the flattening of forms and bold outlines, and to some extent the shadowy figures in the background. However, these figures are also reminiscent of the shadow plays that were fashionable in various cabaret shows at the time, the most famous being at Le Chat Noir, where Lautrec was a regular habitué.

La Goulue's illustrious career came to an abrupt end after stints as a belly dancer and a lion tamer, and she ended up living in a gypsy caravan. Weber makes a brief appearance in the 1928 documentary *La Zone* by Georges Lacombe. Prone to weight gain, her changed appearance as a rotund figure is in startling contrast to the lithe beauty depicted by Lautrec.

Moulin Rouge – La Goulue, 1891. Colour brush and spatter lithograph, printed in black, red, yellow and blue ink, 1655 × 1150 mm

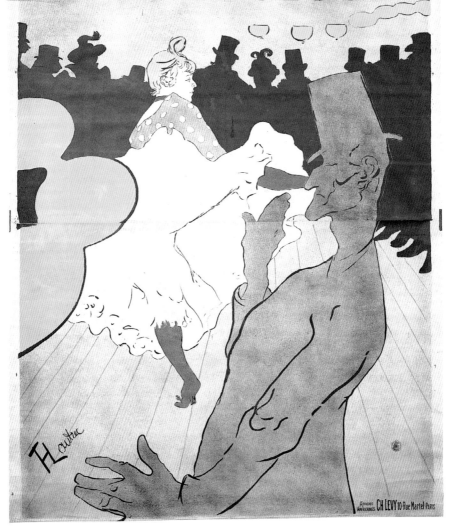

2. *Divan Japonais*

Formerly known as the Café du Divan Japonais, situated in the rue des Martyrs, this venue took on a new lease of life in 1893 when it was transformed by Edouard Fournier into a small artistic café-concert and renamed Divan Japonais. Lautrec was asked to design a poster for the opening. In this memorable image the dancer Jane Avril is silhouetted against the orchestra pit in the unusual role of spectator. Seated next to her is Lautrec's friend, the critic Edouard Dujardin. They are both watching the singer Yvette Guilbert perform on stage, recognizable only by her trademark black gloves.

Praise for the poster and in particular Lautrec's rendering of the figure of Avril appeared in the magazine *La Plume*:

> The svelte spectator with her sharp eye, her provocative lips, her tall, slender, adorably vicious body. What elegance she has, this nervous, neurotic, exquisite creature, a captivating flower that has blossomed . . .
>
> Frantz Jourdain, in *La Plume* (15 November 1893)

The poster was published in January 1893. Unfortunately the revamped Divan Japonais was not a success and before July that year it had closed.

Divan Japonais, 1893.
Crayon, brush and spatter lithograph, printed in black, orange, yellow and olive green ink, 808 × 619 mm

3. *Jane Avril au Jardin de Paris*

This poster celebrates Avril's return to the stage after an absence of two years. She decided to make her comeback at the Jardin de Paris, a café-concert founded by the owner of the Moulin Rouge, and commissioned a poster from Lautrec. The artist had known Avril since 1890 and they remained friends for the duration of his short life.

Born in 1868, Jeanne Richepin anglicized her name to Jane Avril and was nicknamed 'La Mélinite' (melinite was an explosive stronger than dynamite) due to the enormous energy with which she performed. As a young girl Avril was incarcerated at the Salpêtrière mental asylum for a nervous complaint. However, on attending a fancy-dress ball (an idea for therapy by one of the doctors) she discovered that she could dance, which proved to allay her depressive state.

The Jardin de Paris was situated on the Champs-Elysées; a special bus would transfer customers there once the Moulin Rouge had closed at eleven o'clock.

Jane Avril au Jardin de Paris (*Jane Avril at the Jardin de Paris*), 1893.
Colour brush and spatter lithograph, printed in olive green,
black, yellow, orange and red ink, 1225 × 880 mm

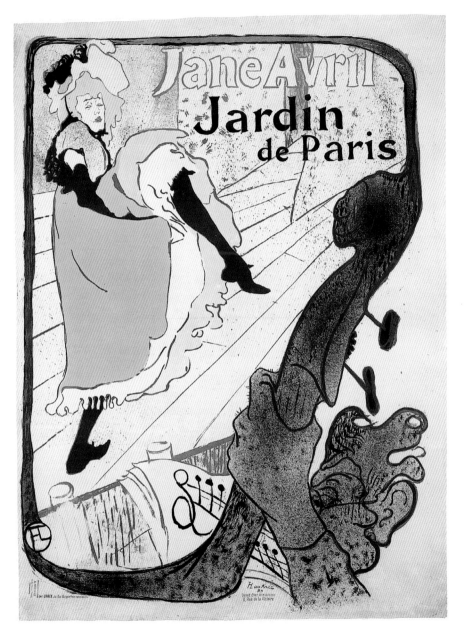

4 · *May Belfort*

One of Lautrec's most striking posters, this image of May Belfort was also used (with added lettering) as a poster for her show at the Petit Casino. Belfort specifically asked Lautrec to make a poster for her performance.

The Irish singer May Belfort (May Egan) worked in the music halls in London before she came to Paris in January 1895. Her slightly disturbing and thinly veiled erotic act was performed wearing the attire of a little girl in a costume akin to Kate Greenaway's illustrations, with large puffed sleeves and an enormous bonnet, often clutching a cat which referred to her most famous song, 'Daddy wouldn't buy me a bow-wow'. It contained the line 'I've got a little cat and I'm very fond of that', which she sung in a provocative fashion. Belfort also specialized in singing old Irish songs and American minstrel melodies.

May Belfort, 1895.
Colour lithograph in red, olive green and yellow ink,
with remarque in grey–brown, 817 × 617 mm

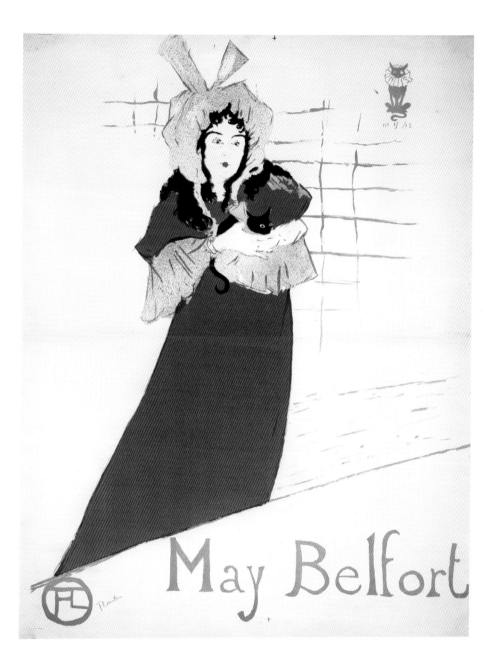

5 · *May Belfort (Grande Planche)*

Lautrec first saw May Belfort perform in 1895 at Les Décadents, a café-concert at 16 bis rue Fontaine. She was the subject of six lithographs executed by the artist that year, in addition to the poster for the Petit Casino (no. 4).

This lithograph is striking as it captures the singer in the harsh glow of the spotlight, emphasizing her aged appearance in stark contrast to her infantile garb. The print also demonstrates the huge impact of the work of Degas on Lautrec's composition and imagery. Like Degas, Lautrec was fond of views of the stage from the orchestra pit and the musician on the left echoes a similar figure in Degas's painting *The Orchestra Musicians* of 1874–6 (Frankfurt, Städelsches Kunstinstitut und Städtische Galerie).

May Belfort (Grande Planche), 1895.
Colour crayon and spatter lithograph, printed in
dark olive green and olive–grey ink, 550 × 420 mm

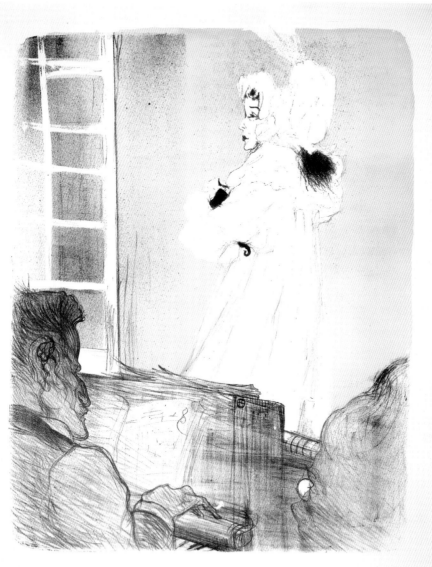

6. *Jane Avril Dancing*

This highly stylized image of Jane Avril dancing is evocatively captured by Lautrec's economic use of curving lines which describe Avril's billowing dress as she energetically performs the can-can. This was the first plate of the album *Le Café-Concert*, published by the periodical *L'Estampe Originale* in an edition of fifty. The album consisted of twenty-two lithographs, eleven by the Dutch-born painter and lithographer Henri Gabriel Ibels (1867–1936) and eleven by Lautrec, with a text by Georges Montorgueil. From around this period Lautrec began to frequent the café-concerts of Montmartre, and inevitably the subject matter of singers and dancers made its way into his work. Many of them, such as Jane Avril, Aristide Bruant and Yvette Guilbert, appear in the *Café-Concert* portfolio.

This print was later used as the cover for a sheet of music published by A. Bosc, 'Alright-Polka-Mazurka – dansée par Jane Avril au Jardin de Paris', also in the British Museum's Department of Prints and Drawings.

Jane Avril Dancing, 1893.
Brush and spatter lithograph,
265 × 212 mm

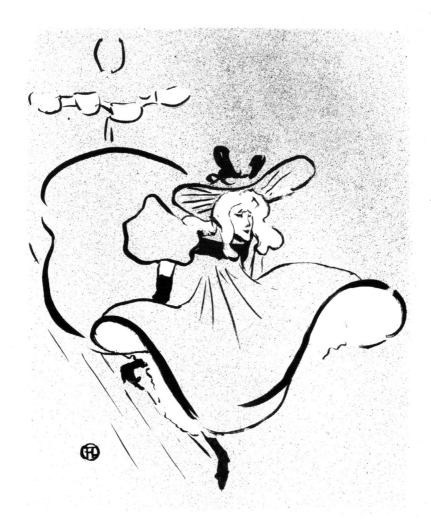

7. *Loïe Fuller*

Born in Illinois, Loïe Fuller (Marie-Louise Fuller, 1862–1928) was a successful performer in the United States before arriving in Paris. Her debut was at the Folies Bergère in 1892, where she perfected a unique and extraordinary act involving mirrors, mechanical machinery and strobe lighting. She twirled around the stage holding wands attached to her dress, giving the impression of an enormous butterfly. A glass floor lit from beneath and mirrors lining the stage enabled Fuller's reflection to be seen ad infinitum by the audience. After forty-five minutes she would be exhausted from her exertions and would have to be carried backstage by a troupe of porters.

Lautrec was dazzled by this performance and endeavoured to recreate Fuller's movements on stage in a series of ambitious prints. Each impression was hand-coloured by the artist, who also added a final heightening of gold or silver powder, a technique borrowed from Japanese prints. The British Museum's impression is an 'épreuve de passe', which means that Lautrec was satisfied with the quality of the impression before an edition was printed. It is also quite a rare print as Lautrec destroyed many of his épreuves.

Loïe Fuller, 1893.
Colour brush and spatter lithograph,
touched with gold powder and printed
on buff paper, 343 × 250 mm

8. *Yvette Guilbert*

This is the cover of a second series of lithographs which Lautrec produced on the singer Yvette Guilbert. Known as the *suite anglaise*, it was commissioned by the English publisher W.H.B. Sands, with a text by Arthur Byl. The first set of prints, the *suite française*, was published in 1894 and consisted of sixteen plates.

Yvette Guilbert (1867–1944) was a distinctive personality and one Lautrec enjoyed portraying, sometimes to the point of caricature, although he had great affection and admiration for her as a singer. Guilbert made her name at various café-concerts and appeared at the Moulin Rouge in 1890. She became established there and projected a very particular image, the genesis of which she describes in her memoirs:

> I was so poor when I started out, and black gloves were the most economical; so I chose black gloves! But I took care to wear them with light-coloured dresses, and to wear them so long that they exaggerated the slightness of my arms, lending elegance also to my shoulders and the carriage of my neck, so long and slender.
>
> Yvette Guilbert, *La chanson de ma vie, mes mémoires* (Paris, 1927)

Unfortunately the *suite anglaise* was a failure; Guilbert was supposed to appear in London in May 1898 but cancelled her performance. Coincidentally, Lautrec's exhibition, organized for the same month at the Goupil Gallery (an English branch had just opened), was also deemed a failure.

Yvette Guilbert, 1898.
Crayon lithograph with scraper, printed on
pale blue–grey paper, 343 × 280 mm (max.)

Yvette Guilbert

Drawn by

H. de Toulouse Lautrec

9. Yvette Guilbert, 'Linger, Longer, Loo'

This lithograph, plate VII from the *suite anglaise*, shows Yvette Guilbert in one of her characteristic poses displaying her famous black gloves to great effect. She struck this pose when she sang the popular English song of the day 'Linger, Longer, Loo'. The writer Edmond de Goncourt had described Guilbert in his journal on 28 June 1893 as having:

> A flat face, a nose like the foot of a pot, eyes of washed-out blue, eyebrows with a slightly satanic upward curve, a coil of bleached hair about the head . . .

Yvette Guilbert, 'Linger, Longer, Loo', 1898.
Colour crayon lithograph, printed in black ink with beige tint stone, 323 × 265 mm (to edge of tint stone)

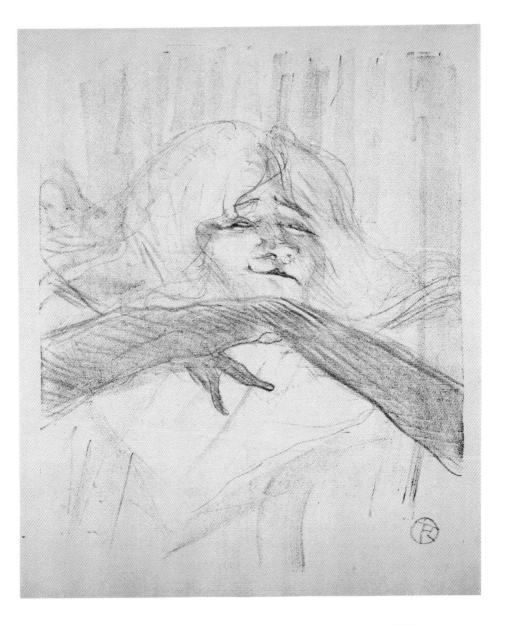

10. *Marcelle Lender, en Buste*

Lautrec was especially fond of the actress Marcelle Lender (Anne-Marie Marcelle Bastien, 1862–1926) and went to see her in Hervé's operetta *Chilpéric* at the Théâtre des Variétés in 1895 on numerous occasions in order, Lautrec said, to admire her magnificent back. In this print, commissioned by Julius Meier-Graefe, the editor of the German periodical *Pan*, the actress is depicted in the role of Queen Galswinthe in *Chilpéric* at the moment that she dances for the king.

Lautrec has drawn Lender in her magnificent headdress from the show. She is caught as if in mid-song, echoing the 'miiye', the prolonged suspension in time practised by Japanese kabuki actors, a technique used to heighten intensity. Lautrec had an extensive collection of Japanese prints, especially kabuki prints.

This is a masterpiece of lithographic printing using eight different colours, thus requiring eight different stones for printing. The British Museum's print is the fourth state which is one of a hundred prints that were published by *Pan* for its French supplement (volume 1, number 3). Meier-Graefe was a great advocate of French artists, but another director of *Pan* criticized Lautrec's frivolous work and poor technique, and Graefe lost his job shortly after the print's publication.

Marcelle Lender, en Buste, 1895.
Colour crayon lithograph,
325 × 243 mm

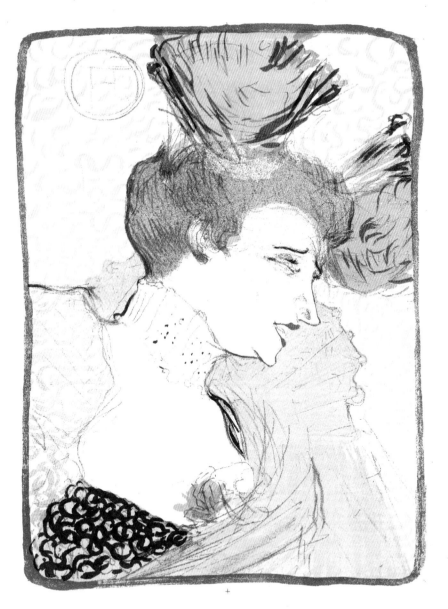

11. *A la Renaissance: Sarah Bernhardt dans 'Phèdre'*

This print was published in the small-circulation illustrated journal *L'Escarmouche* on 24 December 1893. Lautrec portrays the celebrated actress Sarah Bernhardt (1844–1923) as Phèdre in Racine's play of the same name. This was one of Bernhardt's favourite roles and on this occasion the actress (now fifty) revived the part at her own theatre, the Renaissance, in 1893. She is shown clutching her servant's arm, and with the exaggerated tragic facial expression that was her trademark.

Proust's narrator in *A la recherche du temps perdu* (1913) is obsessed with Bernhardt, referring to her as 'Berma':

> My interest in Berma's acting had continued to grow ever since the fall of the curtain because it was no longer compressed within the limits of reality . . . while Berma was on stage, upon everything that she offered, in the indivisibility of the living whole, to my eyes and ear . . . 'It's true!' I told myself. 'What a beautiful voice, what an absence of shrillness, what simple costumes, what intelligence to have chosen *Phèdre*! No, I could not have been disappointed!'
>
> Marcel Proust, *Remembrance of Things Past*,
> transl. C.K. Scott Moncrieff and Terence Kilmartin (Chatto & Windus, 1981).
> Reprinted by permission of The Random House Group Ltd.

Bernhardt never asked Lautrec to produce any work for her but he did portray her as Cleopatra in 1898 for his series *Portraits d'Acteurs et d'Actrices: Treize Lithographies*. There is also a drawing of her as Phèdre by Lautrec, dated 1893, in the Musée du Louvre, Paris.

A la Renaissance: Sarah Bernhardt dans 'Phèdre'
(*At the Renaissance: Sarah Bernhardt in 'Phedre'*), 1893.
Crayon, brush and spatter lithograph, printed
on imitation japan paper, 344 × 228 mm

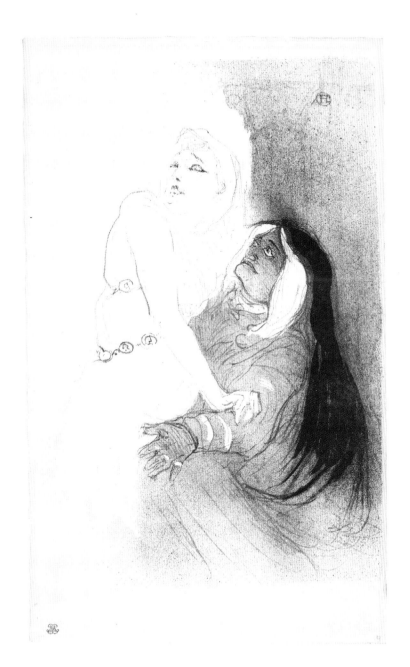

12. *Réjane et Galipaux, dans 'Madame Sans-Gêne'*

This lively and witty print depicts two actors, Réjane (Gabrielle-Charlotte Réju, 1857–1920) and Félix Galipaux (1860–1931), in *Madame Sans-Gêne* (*Mrs Free and Easy*) by Victorien Sardou and Emile Moreau. The play was about a former laundress whose husband is promoted to the rank of Marshal by the Emperor Napoleon. In this scene Madame Lefebvre, played by Réjane, is proving to be an awkward and ungainly pupil as her dancing master Despreaux, played by Galipaux, tries to teach her how to dance the minuet. Lautrec keenly observes the humour of the play and conveys the comic element of the scene through the exaggerated gestures of the actors and their knowing sidelong glances.

Réjane et Galipaux, dans 'Madame Sans-Gêne'
(*Réjane and Galipaux in 'Madame Sans-Gêne'*), 1893.
Colour crayon lithograph, printed in
olive green ink, 310 × 252 mm

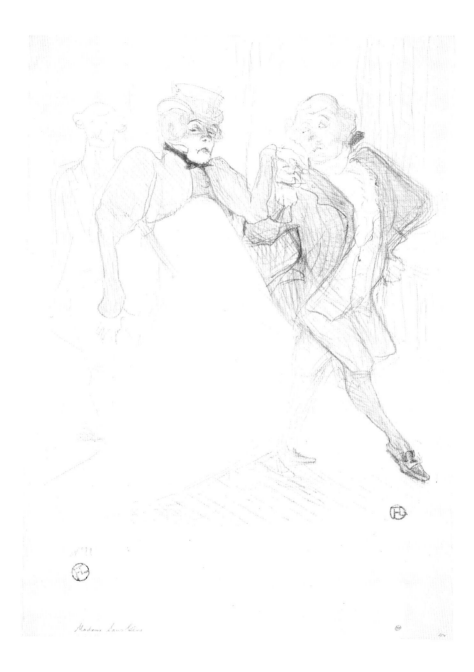

Madame Lanthelme

13. *Carnaval*

This print of two actresses in costume was published in 1895 in the anthology *Album de la Revue Blanche*, in an edition of one hundred. The *Revue Blanche* was a periodical founded in Belgium in 1889. Its offices were transferred in 1891 to Paris, where Thadée Natanson was editor-in-chief. Natanson and his wife, Misia, became great friends of Lautrec, the artist spending weekends at their house which became a meeting place for writers such as André Gide, Paul Valéry and Alfred Jarry. Natanson recalled Lautrec's delight at the use of a second lithographic stone used merely for the red lipstick of the figure on the left.

Carnaval (*Carnival*), 1894.
Colour crayon and brush lithograph with scraper, printed in olive green and red ink; signed with monogram on stone, 246 × 160 mm

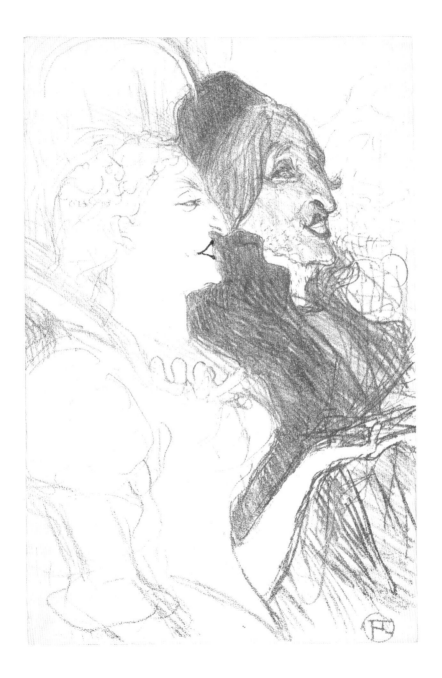

14. *Répétition générale aux Folies Bergère*

Lautrec captures the spontaneity of a dress rehearsal in a working theatre: for example, the scenery in the background suspended by pulleys, not quite ready for the performance. The French writer Colette evokes this atmosphere in *Les Vrilles de la Vigne* (1893), her memoirs of working in the music hall:

> Backstage there is the smell of plaster and ammonia and in the depths of the dim abyss that is the auditorium, disquieting larvae move about hurriedly Nothing is right. The scenery isn't finished, it's far too dark and swallows up the light.
>
> Colette, *Earthly Paradise*, transl. Herma Briffault (Secker & Warburg, 1974)
> Reprinted by permission of The Random House Group Ltd.

This print, published in *L'Escarmouche* (3 December 1893), shows Mariquita, the director of the Folies Bergère ballet, with the dancer Emilienne d'Alençon in a scene from *Bal des Quat'z Arts*, the history of a 'demi-mondaine'. Emilienne d'Alençon (Emilie André) appeared in Lautrec's print *Au Concert* (1896, no. 22) and the artist also included her portrait in the portfolio *Portraits d'Acteurs et d'Actrices: Treize Lithographies*, published in 1898. The Folies Bergère, founded in 1869 on the rue Richer, was described by one contemporary observer:

> It is a special kind of establishment which is related to the café-concert because it serves refreshments and has an orchestra, one of the best in Paris. Its current repertoire consists of ballets, pantomimes, gymnastic exercises and displays of every kind.

Répétition générale aux Folies Bergère
(*Dress Rehearsal at the Folies Bergère*), 1893.
Crayon, brush and spatter lithograph
with scraper, 369 × 258 mm

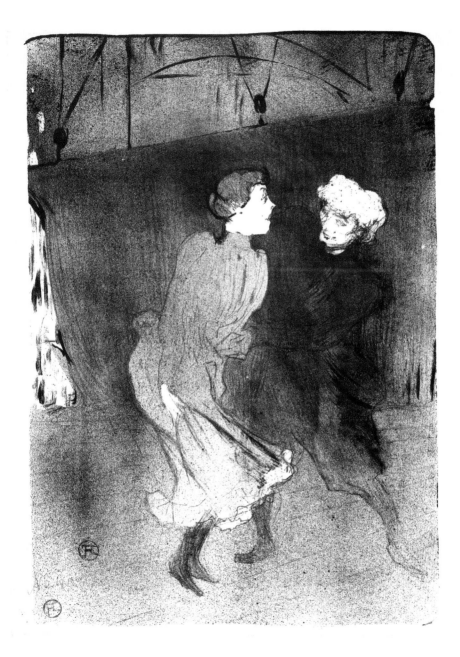

15. *Brandès et Le Bargy au 3ème Acte des 'Cabotins'*

Marthe Brandès (Marthe-Josephine Brunswig) is seen here with the actor Charles Le Bargy in the third act of Edouard Pailleron's *Les Cabotins*, which was staged at the Comédie-Française in 1894. In the play Brandès plays the role of an older woman jealous of her eighteen-year-old rival.

Lautrec was a great admirer of Brandès. In *Paris Illustré* (23 March 1889), the writer Félicien Champsaur described the charismatic actress as having strange features that would have appealed to Lautrec: a cat's reddish brown eyes, an imperious and hard mouth, an angular figure, a harsh voice and the proud brow of a sphinx.

Brandès et Le Bargy au 3ème Acte des 'Cabotins'
(*Brandès and Le Bargy in the 3rd Act of 'Cabotins'*), 1894.
Colour crayon, brush and spatter lithograph with
scraper, printed in olive green ink, 431 × 333 mm

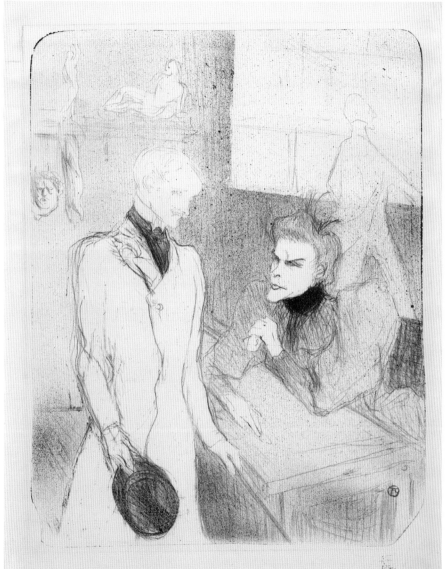

16. *Polaire*

Polaire was the stage name of the actress Emilie Zoé Bouchaud. Born in Algeria in 1877 or 1879, her exotic looks and tiny waist made her an instant success on the Paris stage. She was a close friend of the French writer Colette and her husband, the writer Willy (pseudonym of Henri Gauthier-Villars). Polaire and Colette were to some extent exploited by Willy as he paraded them, identically dressed, around town to promote his 1902 stage play *Claudine à Paris* (adapted from Colette's novel of the same name published in 1901) at the Bouffes-Parisiens with Polaire in the leading role.

Colette described Polaire in her memoirs, *Mes Apprentissages* (1936):

> She was not heavily made up. Except for the bistre shadow of her lids, the mascara of her wonderful long lashes, she glowed with her own radiance that flashed and faded, flashed again, a shining that seemed near to tears in her eyes' sad infinity, a long drawn out unhappy smile.
>
> Colette, *Earthly Paradise*, transl. Helen Beauclerk (Secker & Warburg, 1974)
> Reprinted by permission of The Random House Group Ltd.

This plate was published posthumously in 1930 in *Dessins de Maîtres Français* (vol. IX), devoted to Lautrec with a text by the artist's friend Maurice Joyant. It had been originally intended for the series *Portraits d'Acteurs et d'Actrices: Treize Lithographies* (1898).

Polaire, 1897/8 (1930 edition).
Crayon lithograph, 345 × 225 mm;
one of a posthumous edition
of seventy-five impressions

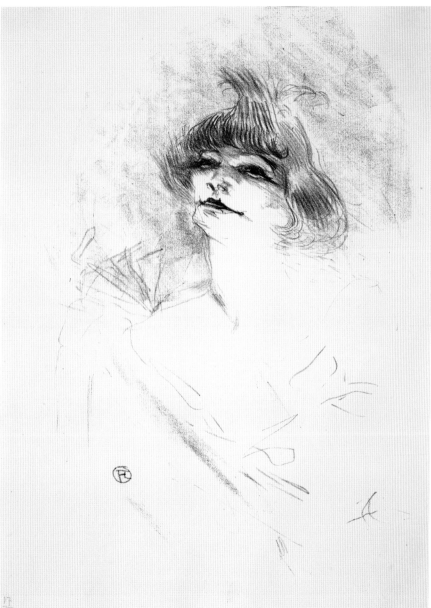

17 · *Coquelin Aîné*

This portrait of the actor Benoît Constant Coquelin (1841–1909) depicts him in the role of Cyrano de Bergerac. The distinguished French playwright Edmond Rostand wrote the part specially for the actor, whom one contemporary critic described as clumsy but unique, qualities wholly suited to the part of the romantic anti-hero Cyrano. This plate, unlike the portrait of Polaire (no. 16), was published in the series *Portraits d'Acteurs et d'Actrices: Treize Lithographies* (1898). The portfolio consisted of head-and-shoulder portraits of many of Lautrec's favourite stage performers, including Sarah Bernhardt, May Belfort, Sybil Sanderson and Emilienne d'Alençon.

Coquelin Aîné (*Coquelin the Elder*) from *Portraits d'Acteurs et d'Actrices: Treize Lithographies*
(*Portraits of Actors and Actresses: Thirteen Lithographs*), 1898.
Crayon lithograph, printed in black ink on greyish china paper,
mounted on card, 280 × 230 mm

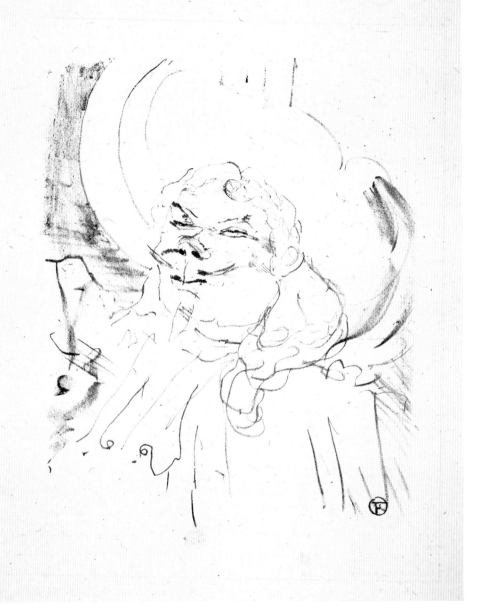

18. *Sybil Sanderson*

Sybil Sanderson (1865–1903) was an American singer who performed at the Opéra-Comique in Paris. Here she is shown in classical costume. This print was also used as the frontispiece of the portfolio *Portraits d'Acteurs et d'Actrices: Treize Lithographies* (1898).

Sybil Sanderson from *Portraits d'Acteurs et d'Actrices: Treize Lithographies* (*Portraits of Actors and Actresses: Thirteen Lithographs*), 1898 (*Les XX* edition, *c.* 1913). Crayon lithograph, 280 × 240 mm

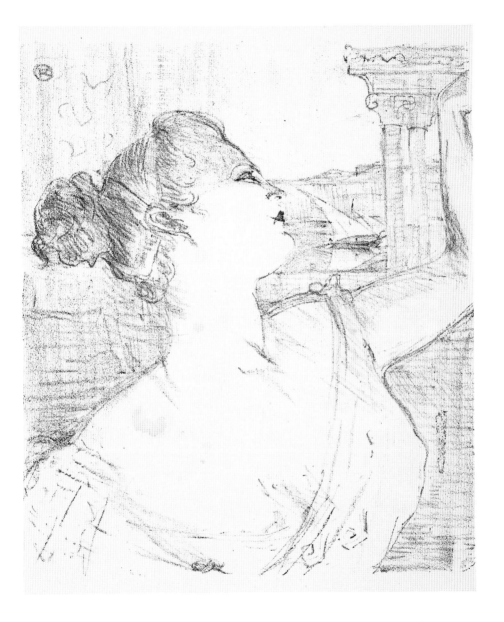

19. *Paula Brébion*

With spare economy of line Lautrec evokes the figure of a singer, either plucking an eyebrow or applying make-up in an intimate backstage scene; she is possibly about to take the stage. Not much is known about Paula Brébion (b. 1869–d. unknown), other than that she was a singer at the Scala. She also performed contortions while she sang in a lisping voice. This lithograph is from Lautrec and Ibels's *Café-Concert* series. It is possible that a black-chalk drawing identical to this print and of the same date in the Museum Boijmans Van Beuningen, Rotterdam, is a study for this print.

Paula Brébion, 1893.
Colour brush lithograph, printed in
light olive green ink, 218 × 172 mm

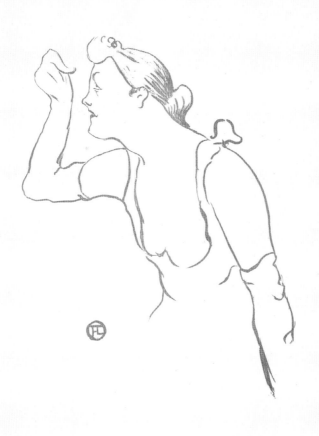

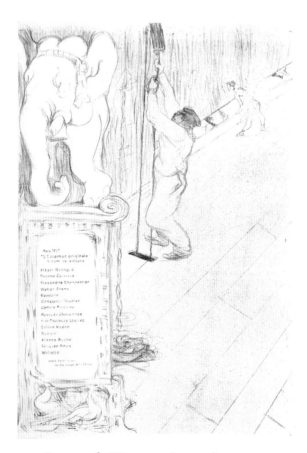

20. Cover of *L'Estampe Originale*

These two prints formed the cover of the last album of *L'Estampe Originale*. They show theatrical life both front of house and behind the scenes. The right-hand print depicts a woman looking onto the stage from a box as the curtain is either rising or just about to fall; the model for the figure was Misia Natanson.

In the other print stagehands are either raising the curtain or pulling it down for a final curtain call; a ballet dancer is poised on stage about to start or end a show. The elephant motif seen on stage appeared on Lautrec's programme for the

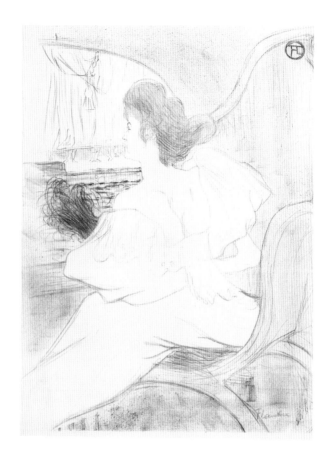

ancient Indian play *Le Chariot de Terre Cuite* (*The Little Clay Cart*), which opened at the Théâtre de l'Œuvre on 22 January 1895. It could also be a reference to the giant papier-mâché model elephant rescued from the Exposition Universelle and placed in the garden of the Moulin Rouge in the 1890s.

Cover of *L'Estampe Originale*, 1895. Colour crayon, brush and spatter lithograph, printed in dark olive green ink on imitation japan paper, 583 × 396 mm (left); 582 × 425 mm (right)

21 · *La Loge au Mascaron Doré*

Spectators at the theatre were often depicted in late nineteenth-century French art. The theatre was the ideal arena from which to observe society at large. In Lautrec's print a lady gazes out at the audience through her opera glasses. She is perched up high in her splendid box decorated by a gilded mask, the 'mascaron doré' of the title.

Parisian society of the late nineteenth century was based on power and money and members of this plutocracy were acutely aware of their social status. The theatre provided a perfect opportunity to see and be seen. In Zola's novel *Nana* (1880), about the rise of an ambitious courtesan, he describes the opening night audience of the Théâtre des Variétés:

> This was Paris: the Paris of literature, finance, and pleasure; lots of journalists, a few authors, stockbrokers, and more tarts than respectable women; a strangely mixed bunch, comprising every kind of genius, tainted with every kind of vice, with the same look of feverish excitement and weariness painted on every face.
> Emile Zola, *Nana*, ed. and transl. Douglas Parmée (Oxford, 1998)
> Reprinted by permission of Oxford University Press.

This print was published by the Théâtre Libre as a programme for their 1893–4 season. The model for the gentleman in the box was Charles Conder (1868–1909), an Australian-born artist who settled in Paris in the late 1890s. He knew Lautrec and often appears in his compositions.

La Loge au Mascaron Doré
(*The Box with the Gilded Mask*), 1893.
Colour crayon, brush and
spatter lithograph, 370 × 310 mm

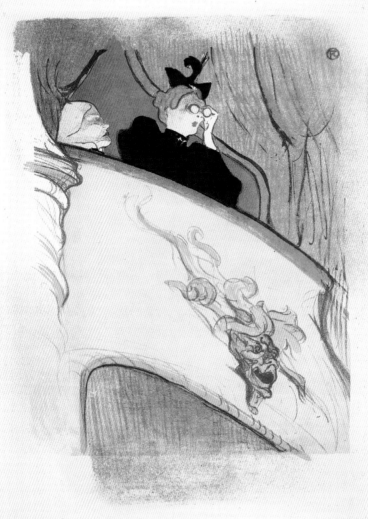

22. *Au Concert*

Lautrec used as his models for the wealthy pair in the theatre box his cousin Gabriel Tapié de Céleyran (1869–1930) and the dancer Emilienne d'Alençon. Lautrec shared his love for the theatre with his cousin and introduced him to Parisian theatrical life when Tapié de Céleyran came to Paris to continue his medical studies. A few years earlier Lautrec had painted his cousin in a corridor of the Comédie-Française; this painting is now in the Musée Toulouse-Lautrec in Albi, which Tapié de Céleyran helped to set up after Lautrec's untimely death.

Au Concert (*At the Concert*), 1896.
Colour brush and spatter zincograph
with scraper, printed in brown, red,
yellow, blue and black ink, 320 × 252 mm

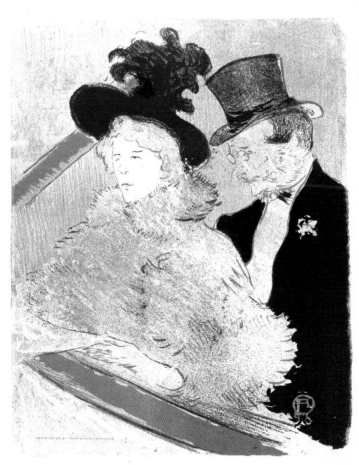

23. *La Petite Loge*

This could be a box at the Souris bar in rue Breda (now rue Henri Monnier). It was a well-known lesbian restaurant. In *Paysages et Portraits* (1958), Colette describes a similar establishment, Semiramis's bar, and skilfully characterizes the type of clientele:

> Can I tell you that while dining at Semiramis's bar I enjoy watching the girls dancing together, they waltz well . . . they are young models, young scapegoats of the neighbourhood, girls who take bit parts at the music-hall, but who are out of work . . .
>
> Colette, *Earthly Paradise*, transl. Herma Briffault (Secker & Warburg, 1974). Reprinted by permission of The Random House Group Ltd.

La Petite Loge (*The Little Box*), 1897.
Crayon and spatter lithograph,
printed in black, red, salmon pink,
yellow and grey–green ink, 238 × 317 mm

24 · Cover of *Les Vieilles Histoires*

This print was the outer cover to a collection
of songs by the poet Jean Goudezki, with music
by the composer and musician Désiré Dihau
(1833–99), a distant cousin of the artist. Dihau is
seen in a top hat with his bassoon under his arm
about to cross the Pont des Arts in the direction
of the Institut Français. He holds a muzzled
bear on a lead which is supposed to represent
Goudezki. The dome of Les Invalides and the
Eiffel Tower can just be seen in the distance.
Lautrec portrayed the poet as a bear because
Goudezki was a vociferous speaker and used to
hurl abuse at the audience at Le Chat Noir.

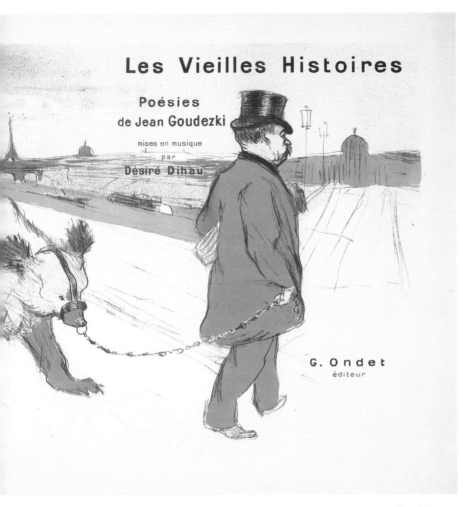

Cover of *Les Vieilles Histoires* (*The Old Tales*), 1893.
Colour crayon and spatter lithograph, 338 × 541 mm

25. *La Valse des Lapins*

This charming print is a rare first state. The print was used with lettering as the cover of a song-sheet for 'La Valse des Lapins', a song by L. Durocher set to music by Désiré Dihau.

A musician at the Paris Opéra and a composer of light songs, Dihau was famously portrayed playing his bassoon in Degas's painting *L'Orchestre de l'Opéra* of 1869 (Paris, Musée d'Orsay). Lautrec consciously echoes this painting as a homage to his idol Degas in the print *Pour Toi!* . . . (see the frontispiece), which shows Dihau in a similar pose to the Degas painting, but with a bust of Pan behind him. It was through Dihau that Lautrec eventually got to meet Degas.

Designing song- and music-sheets was a common source of income for an artist in 1890s Paris and also ensured that their work was able to reach a wider audience. Lautrec's sensitivity in portraying animals was further exemplified in his illustrations for Jules Renard's *Histoires Naturelles* (1897–9).

La Valse des Lapins (*The Rabbits' Waltz*), 1895/6.
Crayon, brush and spatter lithograph, 315 × 235 mm

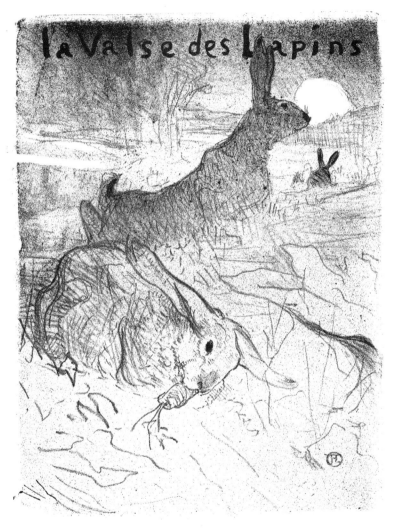

la Valse des Lapins

26. *Oscar Wilde et Romain Coolus*: Programme for *Raphaël* and *Salomé*

This print was used as the programme for the double bill of Romain Coolus's *Raphaël* and Oscar Wilde's *Salomé* at the Théâtre de l'Œuvre in February 1896. The actor-manager of the theatre, Aurélien-Marie Lugné-Poe (1869–1940), commissioned the print from Lautrec. The artist places both authors against a background from their native cities. René Weil (1868–1952) wrote under the pen name Romain Coolus; he was a close friend of Lautrec and a member of the *Revue Blanche* circle. He is portrayed as a man about town with the Arc de Triomphe in the background, while Big Ben is referenced in the shadowy scene behind Lautrec's depiction of Wilde. Wilde had been imprisoned the year before and Lautrec had attended his trial in London. Wilde was touched that his play was to be performed in Paris. Writing from prison to Robert Ross, he mourned:

> It is precious to me that in this time of disgrace and shame I can still be considered an artist. I wish I could feel more pleasure but it seems that I am dead to all feelings save those of anguish and despair.
> Oscar Wilde, letter to Robert Ross (10 March 1896)

Salomé was to have been performed in London in 1892 with Sarah Bernhardt in the leading role but was banned by the censor. This Parisian production was the first public performance of the play and took place on 10 February 1896.

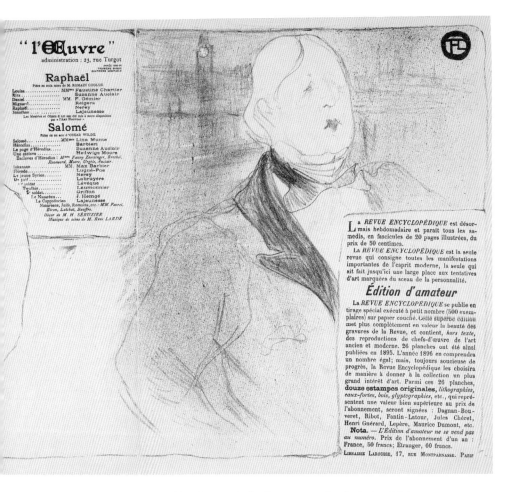

Oscar Wilde et Romain Coolus: Programme for *Raphaël* and *Salomé*, 1896.
Crayon, brush and spatter lithograph, 300 × 490 mm

27. 'Pauvre Pierreuse!'

'Pauvre Pierreuse!' ('pierreuse' is slang for prostitute) was a song from the repertoire of the singer Eugénie Buffet (1866–1934). Buffet specialized in songs about poor, exploited women who lived in fear of their pimps and clients on the notorious Butte de Montmartre. She had the reputation of being a firebrand and was once imprisoned for fifteen days for shouting 'Vive Boulanger!' (General Boulanger was a right-wing opponent of the Government of the Republic). Incarcerated at the Saint-Lazare prison she met at first hand the heroines of her songs.

It has been suggested that the woman represented in this print is Buffet herself. It is unclear whether she is being led away by a potential client or pursuing him. Although this print was originally the cover for a song-sheet published by the music publisher G. Ondet, one thousand proofs before letter were published by Kleinmann, Lautrec's print agent.

'Pauvre Pierreuse!' ('Poor Prostitute!'), 1893.
Colour brush lithograph, printed
in olive green ink, 225 × 140 mm

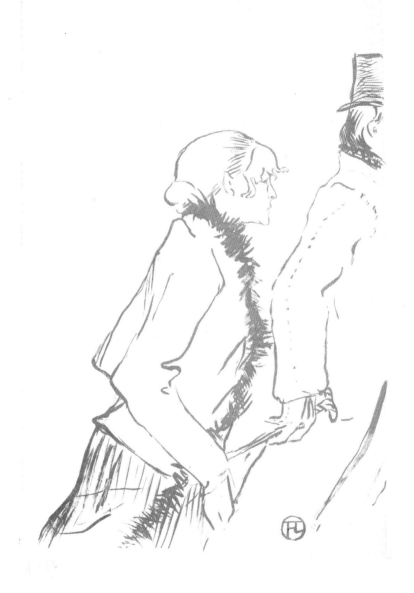

28. *Le Coiffeur*

Like *'Pauvre Pierreuse!'*, this image of a prostitute having her hair combed and with her lips pursed in an expression of vanity was published without letters as an edition for collectors. It was used with lettering as a programme for the Théâtre Libre.

Le Coiffeur (The Hairdresser), 1893.
Colour crayon and brush lithograph,
printed in dark olive green, red and
yellow ink, 325 × 245 mm

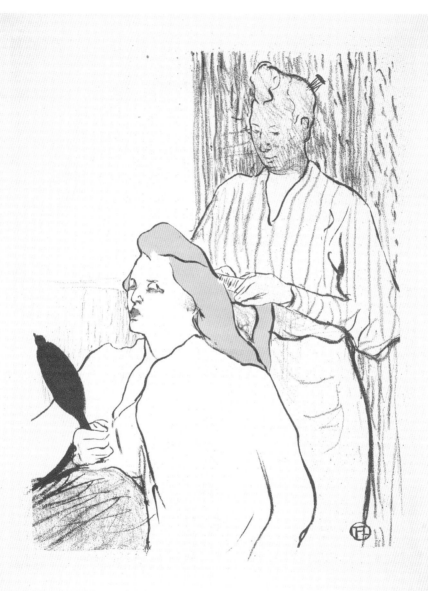

29. Frontispiece to *Elles*

The portfolio of prints entitled *Elles* was published by the collector Gustave Pellet. He had become a publisher of semi-erotic prints for financial reasons, issuing works by artists such as Félicien Rops, and had also published other prints by Lautrec. It is not known whether *Elles* was commissioned by Pellet, but Lautrec produced this series of eleven prints together with an extra print, *Le Sommeil*.

Though the subject matter of the *Elles* album shows the quotidian nature of life as a prostitute, it is infused with both wit and pathos. It conveys the deep boredom involved in waiting for clients and the intimate private world of women, the 'Elles' of the title.

The *Elles* series is the result of Lautrec's residence at several brothels between 1893 and 1894; during this period Lautrec painted many images of prostitutes waiting for clients or attending the obligatory medical inspections. Surprisingly the *Elles* album does not contain many overt images of a sexual nature. Prostitution is only hinted at and never is any explicit reference made to the occupation of the inhabitants of the maison close, literally 'closed house' as the police insisted that during the day such establishments should always have the shutters closed and the curtains drawn.

Indeed, if anything, the album lacks cohesion, which may be the reason why it proved to be a commercial failure. The print illustrated here was used as the frontispiece to the album and a monochrome version was used as the cover. A full-sheet edition using the same image was used to advertise the exhibition of the series at the gallery of *La Plume*, an artistic journal of the period.

Frontispiece to *Elles*, 1896.
Colour crayon, brush and spatter lithograph,
printed in olive green, blue and orange ink,
520 × 400 mm

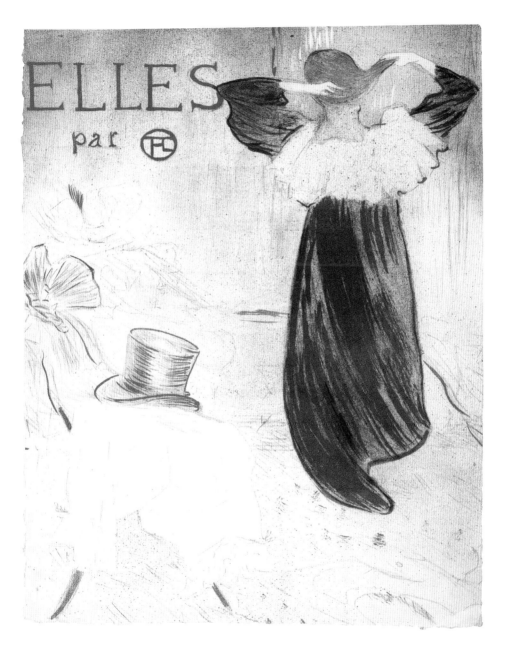

30. *Elles: La Clownesse Assise*

Very little is known about the female clown known as Cha-U-Kao (pronounced 'chahut-chaos', the wild can-can-like dance performed around Paris at the time) who appeared at the Moulin Rouge and the Nouveau Cirque. She appears in Lautrec's work around this period, always wearing her distinctive costume: baggy black trousers and a yellow ruff. It is odd that this is the first print in the album; perhaps it is linking the public world of the theatre, inhabited by such figures as Cha-U-Kao, with the private, often claustrophobic, world of the maison close.

Elles: La Clownesse Assise (*The Seated Clowness*), 1896.
Colour crayon, brush and spatter lithograph with
scraper, printed in green–black, black–brown,
yellow, red and blue ink, 525 × 405 mm

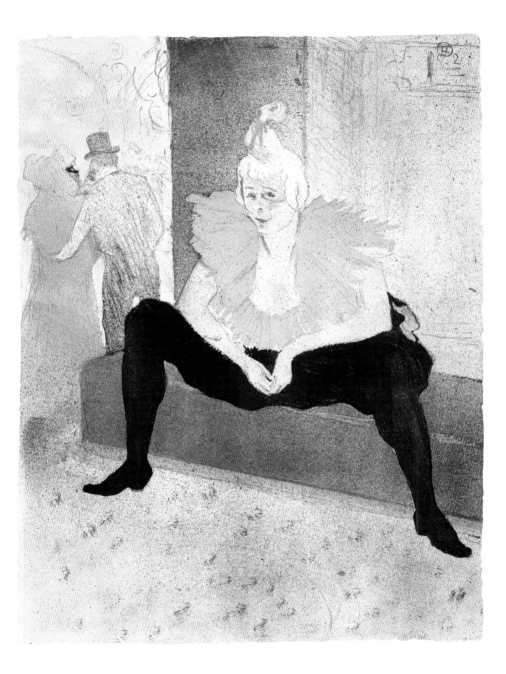

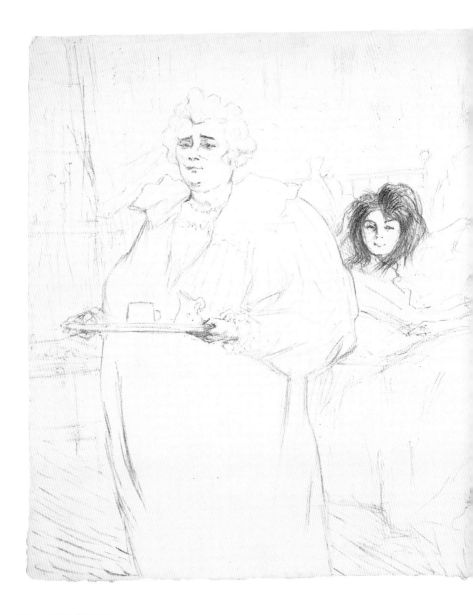

31. *Elles*: *Femme au Plateau* — *Petit Déjeuner*

This delicately executed print shows a girl leaning up in bed with tousled hair. She has just been served breakfast by an older woman. The young girl is often identified as Mademoiselle Pauline (or 'Popo' as she was known) who had been Lautrec's mistress; the older woman is her mother, Madame Baron.

Lautrec's public for an album such as *Elles* would have interpreted the scene as representing the world of the prostitute. Depictions of an older woman serving a younger one as a maid usually indicated a mother–daughter relationship, with the former acting as the servant and the latter as the prostitute. Such images were commonplace in contemporary illustrations and caricatures.

Elles: *Femme au Plateau* — *Petit Déjeuner*
(*Woman with a Tray* — *Breakfast*), 1896.
Colour crayon lithograph with scraper, printed in sanguine ink, 403 × 522 mm

32. *Elles: Femme Couchée – Réveil*

This image of a woman waking up in bed perfectly exemplifies the sensuous nature of Baudelaire's verse:

> She was lying down and let herself be loved
> and from the divan's height she smiled for
> pleasure at my passion, deep and gentle as the
> sea rising towards her as towards its cliff.
> Her eyes fixed on me, like a tame tiger, with a
> vague dreamy air she tried various positions,
> and ingeniousness joined to lubricity gave
> her a new charm to her metamorphoses.
>
> Charles Baudelaire, *Les Bijoux* (*The Jewels*)
> from *Les Fleurs du Mal* (1857)

Elles: Femme Couchée – Réveil
(*Woman Reclining – Waking Up*), 1896.
Colour crayon lithograph with scraper,
printed in olive green ink, 402 × 526 mm

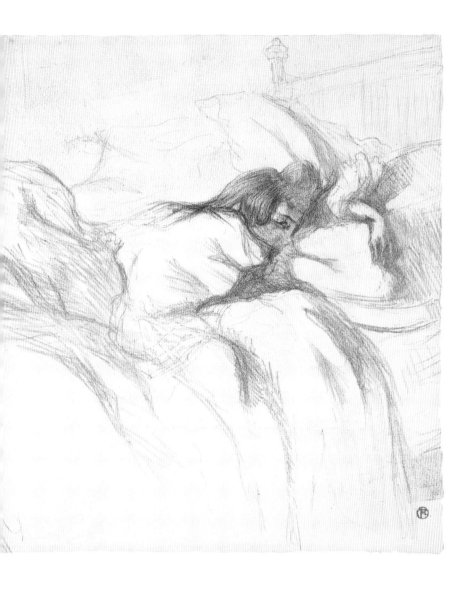

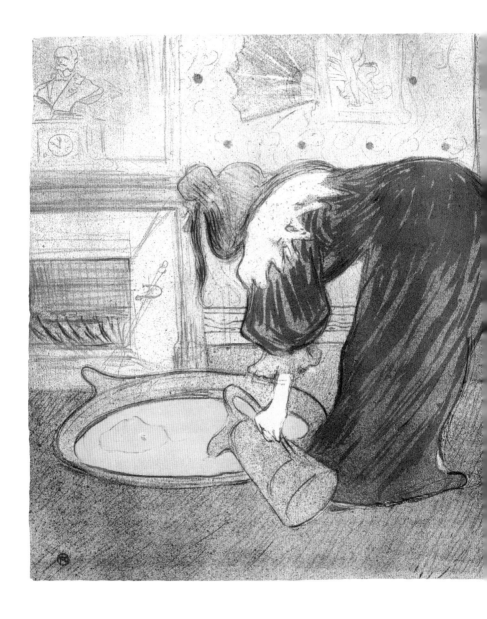

33. *Elles*: *Femme au Tub — Le Tub*

Although not overtly erotic, the *Elles* album took its precedent from Japanese prints of courtesans, such as those by the master Utamaro. Known as 'works of the green houses' (houses of courtesans), Lautrec was intimately acquainted with images of this kind through his connection with Maurice Joyant (1864–1930), director of the Goupil Gallery, who gave the artist the opportunity to study a huge collection of albums by Hokusai, Utamaro and others.

This work has the conscious feel of a Japanese print, with its concentration on the flattening out of shape, form and colour, and the positioning of the woman, her face unseen and her top knot even hinting slightly at a Japanese geisha hairstyle.

Elles: *Femme au Tub — Le Tub*
(*Woman at the Tub*), 1896.
Colour crayon, brush and spatter
lithograph, 404 × 525 mm

34. *Elles: Femme qui se Lave — La Toilette*

This beautiful study of a monumental nude figure performing such an intimate task immediately puts the viewer in the position of voyeur: one can just glimpse the woman's breasts in the tiny mirror. It is difficult to comprehend today how such a private aspect of a woman's daily routine in the late nineteenth century would appear to Lautrec's audience. The artist's work of this nature provides an insight into a world never seen by men. Ordinary bourgeois housewives maintaining the role of 'angel in the house' would never have permitted their husbands to view such an intimate ritual of their daily lives, and even prostitutes would have performed such a task away from the gaze of their clientele. Lautrec had privileged access to such a world and enjoyed the 'family'-like atmosphere of the brothels where he was treated kindly and not as any kind of threat. This image also makes reference to Degas's pastel studies of bathers from the 1880s, especially *The Tub* (1886; Paris, Musée d'Orsay).

Elles: Femme qui se Lave — La Toilette
(*Woman Washing*), 1896.
Colour crayon lithograph, printed in
olive green and blue ink, 525 × 407 mm

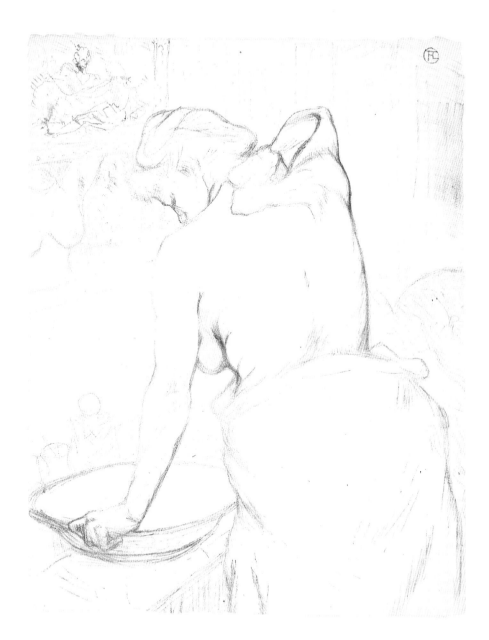

35. *Elles: Femme à Glace — La Glace à Main*

This figure is slightly older than the other women represented in the series. Lautrec catches her in an off-guard moment contemplating her face in a hand-held mirror, possibly pondering how long she has left in such a profession as prostitution. The bed is unmade, indicating that she may just have finished an assignation or has just got up and is about to start her day. Lautrec provides the viewer with mere suggestions in this series, never stating the obvious.

Elles: Femme à Glace — La Glace à Main
(*Woman with Mirror — Mirror in Hand*), 1896.
Colour crayon, brush and spatter lithograph, printed
in grey, yellow and brown–beige ink, 520 × 400 mm

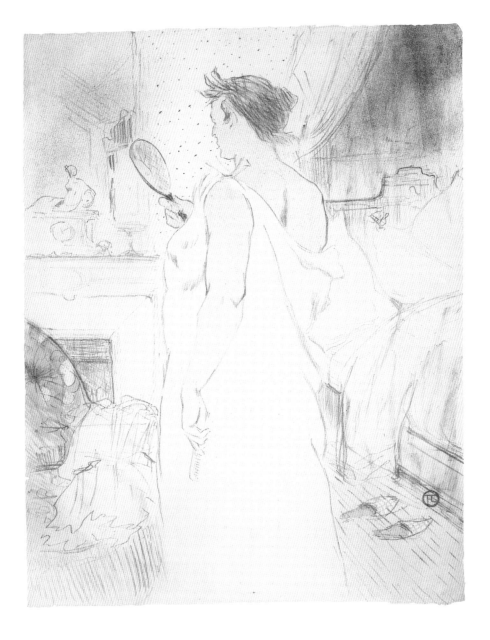

36. *Elles*: *Femme qui se Peigne — La Coiffure*

This beautiful print showing a woman seated on the floor, semi-dressed and combing her hair, is reminiscent of a Japanese courtesan print. Edmond de Goncourt, writing in admiration of the Japanese artist Utamaro's prints of this nature, points out traits in his work that could equally be applied to Lautrec:

> . . . an idealistic depicter of women, but an uncommon one, idealistically representing woman's type, her physique, her anatomical build, while remaining faithful to her most naturalistic attitudes, her movements, the sign language of her graceful humanity.
>
> Edmond de Goncourt, *Outamaro, Le Peintre des Maisons Vertes* (Paris, 1891)

Elles: *Femme qui se Peigne — La Coiffure*
(*Woman Brushing her Hair*), 1896.
Colour crayon, brush and spatter lithograph, printed
in mauve–brown ink with tint stone in pale olive green,
520 × 385 mm

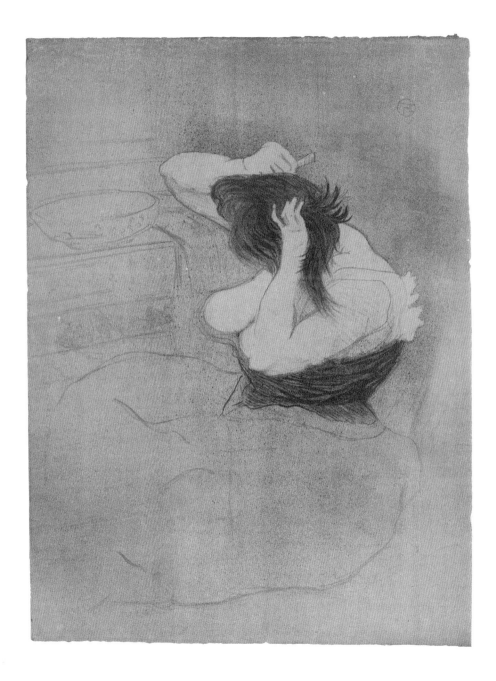

37. *Elles: Femme au Lit, Profil — au Petit Lever*

Lautrec portrays two women, possibly Mademoiselle Popo and her mother, Madame Baron, almost as if they are protagonists in a play. They appear like caricatures, Madame Baron trying to suppress a smile as she prepares to perform some task for her wilful daughter. However, the print can be read another way as it has been suggested that the *Elles* series follows the relationship of a lesbian prostitute couple. Such relationships were common in brothels and Lautrec depicted many tender lesbian scenes in his paintings from this period.

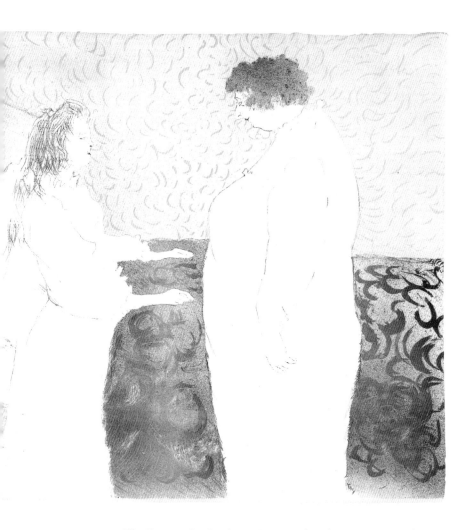

Elles: Femme au Lit, Profil — au Petit Lever (*Profile of a Woman in Bed*), 1896.
Colour crayon, brush and spatter lithograph with scraper, printed in olive green,
grey, yellow and red; signed with monogram on stone, 405 × 528 mm

38. *Elles: Femme en Corset — Conquête de Passage*

Lautrec captures the anticipation of the purely financial liaison between the prostitute and client perfectly. The man on the bed is lasciviously surveying his purchase.

That a woman could be seen as both a commodity and a corrupter of society was a view prevalent in late nineteenth-century Paris. The sense of rottenness is exemplified in the piece written about the life of a prostitute by the journalist Fauchery in Zola's novel *Nana* (1880):

> She'd been brought up on the streets in a working-class Paris slum and now, a
> tall and lovely girl with a magnificently sensual body, like a plant flourishing on
> a dung-heap, she was avenging the poor, underprivileged wretches from whom
> she'd sprung. While the people were left to rot in degraded circumstances, she
> would carry this pollution upwards to contaminate the aristocracy. She was
> turning into a force of nature and, without any intention on her part, a ferment
> of destruction; between her plump white thighs, Paris was being corrupted and
> thrown into chaos; she was making it rot in the same way as, every month,
> women make milk go sour.
>
> Emile Zola, *Nana*, ed. and transl. Douglas Parmée (Oxford, 1998)
> Reprinted by permission of Oxford University Press.

Elles: Femme en Corset — Conquête de Passage
(*Woman in a Corset — Passing Conquest*), 1896.
Colour crayon, brush and spatter lithograph
with scraper, 523 × 405 mm

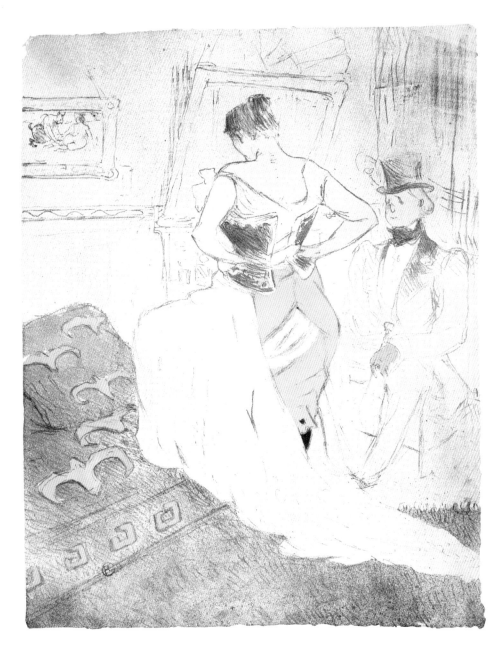

39. *Elles: Femme sur le Dos — Lassitude*

In this, the last print in the *Elles* series, a woman is shown lying on her back, her hands placed behind her head. She has the unmistakable air of relief. Her client gone, she can devote herself to complete relaxation until her next appointment. Here Lautrec gives us an insight into the totally private world of this woman.

It has been suggested that these intimate views of prostitutes offered Lautrec a wealth of interesting and original female poses that he would never have elicited from professional models, thereby providing at the time an almost shocking revelation of the private world of the female other ('Elles' is the feminine for 'them' in French), whether prostitute or not.

Elles: Femme sur le Dos — Lassitude
(*Woman on her Back — Lassitude*), 1896.
Colour crayon lithograph, printed in sanguine
ink with tint stone in olive green, 395 × 525 mm

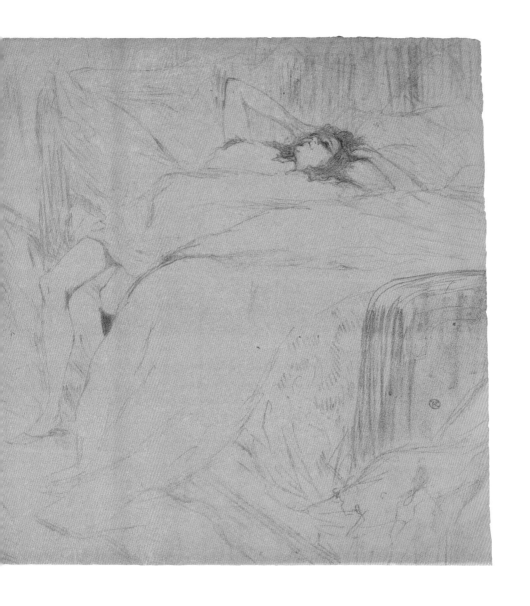

40. *La Passagère du 54 – Promenade en Yacht*

The elegant red-headed woman seated on a deckchair was a mysterious fellow passenger staying in cabin 54 on the *Chili*, a cargo liner that Lautrec took every year from Le Havre to Bordeaux. On this occasion he was so captivated by this woman that he stayed on the boat all the way to Lisbon. Unfortunately she was married and on her way to Dakar to meet her husband. Lautrec's friend Maurice Guibert, who was travelling with the artist, convinced him that his unrequited love was a bad idea and persuaded him to disembark at Lisbon. Guibert took many photographs of the woman and Lautrec probably worked from one of these in order to produce this image.

La Passagère du 54 – Promenade en Yacht
(*The Passenger in Cabin 54 – Yachting*), 1896.
Colour brush, crayon and spatter lithograph,
610 × 450 mm

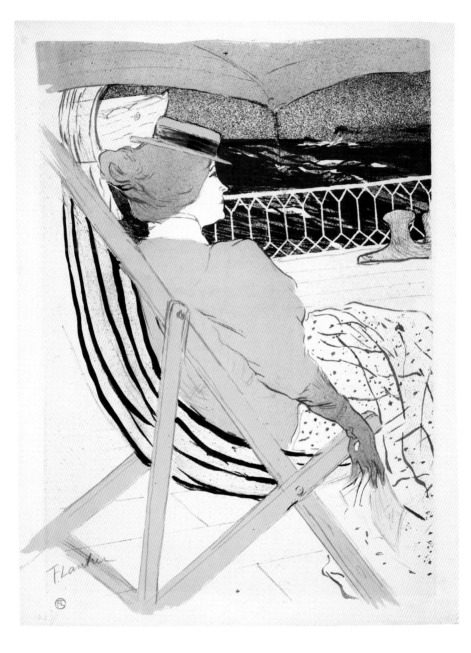

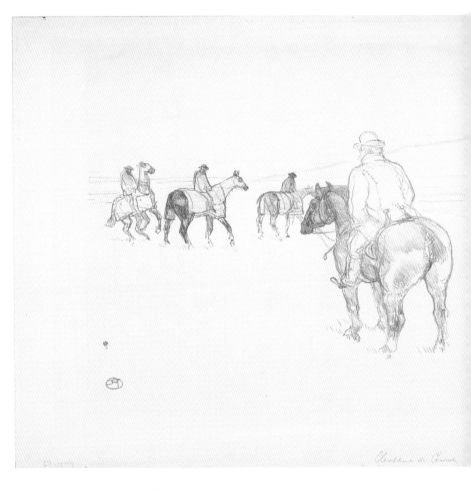

L'Entraîneur (*The Trainer*), 1898/9.
Colour crayon lithograph,
printed in blue ink, 231 × 445 mm

41. *L'Entraîneur*

This print is from a series on horse racing. The prints were planned for the series showing the phases in the preparation for a horse race: *Le Paddock*, *Le Jockey se Rendant au Poteau* (*The Jockey Going to the Post*) and *Le Jockey* (no. 42). These prints exist only in proofs and Lautrec was encouraged to execute them by the publisher M.E.I. Pierrefort who met the artist in 1899 in hospital in Neuilly, where Lautrec was being treated for alcohol abuse. The print closely echoes Degas's painting *The Parade* of 1866–8 (Paris, Musée d'Orsay) in the alignment of the figures on horseback.

42. *Le Jockey*

Le Jockey was the only print published from the series of racing prints promised to the publisher Pierrefort. Unfortunately Lautrec only managed to complete four prints before falling desperately ill. It is one of the most powerful prints ever produced by Lautrec. The jockeys have their heads down and shoulders raised in the position that will give them maximum speed around the track at Longchamps. All the power of the horses is concentrated in their hindquarters, and their coats are shining with sweat.

Le Jockey (*The Jockey*), 1899.
Colour crayon lithograph,
printed on japan paper,
520 × 366 mm

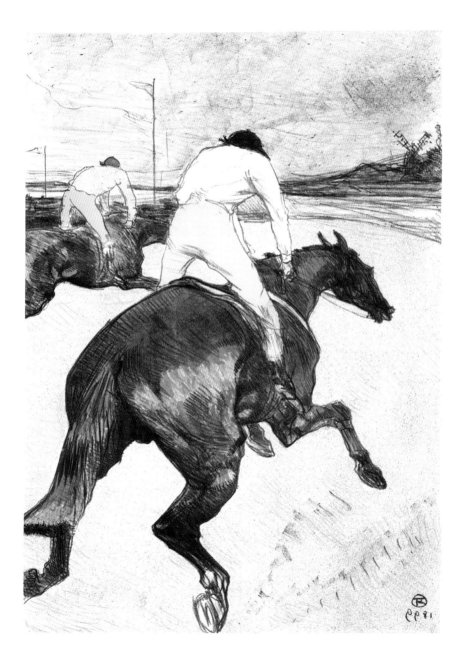

43. *Partie de Campagne*

It is unusual for Lautrec to portray his subjects in
this way, elegantly attired, in the open air, riding in a
carriage ostensibly on their way to some bucolic idyll
in the country. Such characters in Lautrec's works are
usually peering out from a theatre box or belong to the
claustrophobic world of the café-concert. This print
makes reference to many similar outings Lautrec made
as a child with his family, or possibly visits with his
great friends the Natansons to their country house near
Villeneuve-sur-Yonne.

Partie de Campagne (*A Drive in the Country*), 1897.
Colour crayon, brush and spatter lithograph,
395 × 520 mm

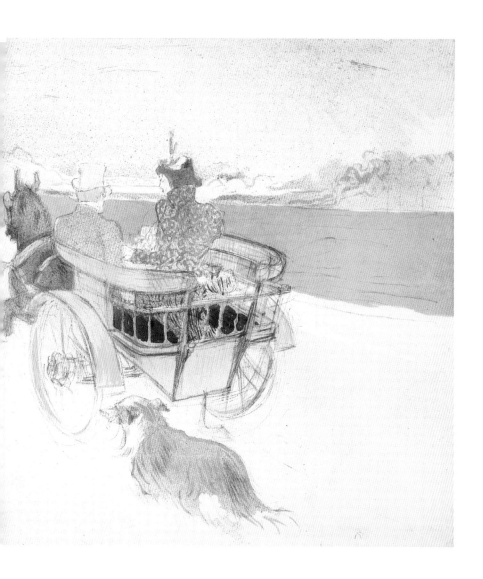

FURTHER READING

J. Adhémar, *Toulouse-Lautrec, Complete Lithographs and Drypoints*, New York, 1965.

W. Wittrock, *Toulouse-Lautrec: The Complete Prints* (2 vols), London, 1985.

F. Carey and A. Griffiths, *From Manet to Toulouse-Lautrec. French Lithographs 1860–1900*, exh. cat., British Museum, London, 1978.

C. Turner and M. Sourgnes, *Toulouse-Lautrec: Prints and Posters from the Bibliothèque Nationale*, exh. cat., Queensland Art Gallery, Brisbane, 1991, from which are taken the translations of the quotations reproduced on pp. 26, 36, 38 and 80.

R. Thomson *et al.*, *Toulouse-Lautrec*, exh. cat., Hayward Gallery, London, 1991, from which are taken the translations of the quotations reproduced on pp. 5, 10, 12 and 24.

ILLUSTRATION REFERENCES

Photographs © The Trustees of the British Museum, courtesy of the Department of Prints and Drawings (PD), unless otherwise noted.

Page		Page		Page	
2	PD 1949-4-11-3609	37	PD 1922-12-18-6	67	PD 1925-10-14-1
11	© V&A Images/Victoria and Albert Museum	39	PD 1949-4-11-3619	69	PD 1949-4-11-3635
		41	PD 1949-4-11-3646	70–1	PD 1949-4-11-3637
13	PD 1929-6-11-71	43	PD 1949-4-11-3627	72–3	PD 1949-4-11-3636
15	© V&A Images/Victoria and Albert Museum	45	PD 1920-8-20-3	74–5	PD 1949-4-11-3638
		47	PD 1949-4-11-3614	77	PD 1949-4-11-3639
17	PD 1925-10-7-3	48	PD 1920-5-22-43	79	PD 1949-4-11-3640
19	PD 1949-4-11-3624	49	PD 1920-5-22-44	81	PD 1949-4-11-3641
21	PD 1949-4-11-3613	51	PD 1949-4-11-3611	82–3	PD 1922-7-8-30
23	PD 1977-11-5-14	53	PD 1922-12-18-8	85	PD 1949-4-11-3642
25	PD 1920-8-7-1	54–5	PD 1949-4-11-3644	86–7	PD 1949-4-11-3643
27	PD 1920-8-7-9	56–7	PD 1920-5-22-42	89	PD 1914-3-24-6
29	PD 1922-7-8-29	59	PD 1922-12-18-7	90–1	PD 1949-4-11-3631
31	PD 1949-4-11-3617	60–1	PD 1922-12-30-36	93	PD 1949-4-11-3650
33	PD 1949-4-11-3618	63	PD 1949-4-11-3612	94–5	PD 1914-3-24-5
35	PD 1949-4-11-3620	65	PD 1949-4-11-3610		